A LESSER
PHOTOGRAPHER

CJ CHILVERS

Second Edition

Keep up-to-date with changes and additions to this book at cjchilvers.com.

INTRODUCTION

Since the age of twelve, I've been obsessed with photography. I built a little darkroom and took class after class to learn as much as I could. I studied the zone system for years until it became so ingrained that I saw the entire world in zones of light. My library of photo books and magazines could rival a university.

By any measure, this is a passion.

Much like a car mechanic would remember the years by the cars he owned, I remember 1994 as the year of my Minolta X-700 or 1996 as the year I stepped up to a Fuji GS645. With every issue of Shutterbug, I scanned the ads in the back pages, lusting after the latest gear I couldn't afford.

The digital age only reinforced my desire to own ever more capable equipment as brands consolidated. Are you a Canon or a Nikon? If so, how high do you rank in that world?

I put that question to rest for myself when I was hiking through Starved Rock State Park in Illinois with my friend Tom Polous.

Tom and I have been best friends since we were nine years old and been enablers of each other's photographic obsessions since the 1990s. On this hike through Starved Rock, Tom had the

latest, greatest Canon DSLR around his neck, and I had a lesser model.

After a few minutes on the trail, we encountered two locals, both with Canon DSLRs. For ten minutes, we discussed our love for the lenses in our bags, and that's when it hit me. This was ridiculous. Four photographers, in the most beautiful of settings, had chosen to discuss gear instead of taking a single photo. Our love of gear had superseded our love of the image.

I slowly backed away from the conversation and began shooting what turned out to be some of my favorite images of that decade.

The questions had been building for years. Just how much did equipment matter, and why? What if I threw it all away and restarted with the minimum amount of equipment? Would my creativity be enough to capture the images I wanted?

I sold my 4x5 view camera, my medium format cameras and my DSLR. I bought an inexpensive compact camera and became determined to put my theories to the test.

Over the next several years, I blogged about my experiences and collected the wisdom of like-minded photographers. I titled the blog A Lesser Photographer, partly to refer to the looks other photographers gave me when I showed up to a shoot with my compact camera.

This book collects my favorite essays from the blog in one place. All the essays have been re-edited, remixed, and condensed, and in some cases, new essays were written to better express an idea.

You'll notice there are no photos inside this book, for the same reason there were very few photos on the blog. I want you to consider your photographs while reading, not mine.

Some of the chapters are about the kind of photography the public will see, and some are about the everyday photos that no one outside our friends and family will see. These two sides of

amateur photography have principles that can be directly in conflict. I'll leave it to you to consider your own goals with your photographs in these chapters.

I hope these little essays to myself help you in your path as a photographer. Feel free to drop by cjchilvers.com and let me know about your own lessons learned.

1

HOW TO MAKE PERFECT PHOTOS

"It's the one art form that everybody is capable of performing flawlessly." — David Strettell

What's the secret to creating great photos? The biggest secret in photography is that you're already making perfect photos. You've been told that you're not because of the second-biggest secret: the teaching of photography has always and will always make more money than the photographs themselves.

This is why professional photographers are trying to get you to buy a new camera or buy a spot in their next workshop. Believe me, they would rather be taking pictures. That's what's most fun about being a photographer.

But that's not where the money is. The money is in convincing you that your composition needs a little work, or your lens has an aberration that a prime lens wouldn't.

The professionals don't do this maliciously. It's how they learned, and it's what they need to do if they want to make a

decent living. For most of us, though, their advice does not apply.

What defines a perfect photo is entirely up to you. Otherwise, this wouldn't be an art. It would be just another commodity, subject to a checklist written long ago.

There is no checklist. Be wary of anyone trying to sell you access to one.

2

HOW TO CREATE FINE ART

"Art is anything we do, after the chores are done." — Teller

There's been a lot of handwringing among the art crowd to explain away the democratization of photography. To differentiate between what qualifies as "fine art" and what is the work of a hobbyist, the art crowd likes to make excuses about how hard it is to create a great photo.

Some variation of "snapshots are easy, great photography is near impossible" or "it takes years of hard work" are repeated endlessly to justify entire careers, or just a large purchase. One is led to believe that great photographers are scarce and fine-art photography may be dying out.

We're not watching the dying of photography as a fine art. What we're really watching is the dying of a concept, the concept that good ideas in photography, ideas worthy of the gallery, are scarce. They're not. They've never been. Connections in the fine-art market are scarce.

No one gets to tell you what qualifies as "fine" art. Nor could they.

THE NEW RULES OF PHOTOGRAPHY

"I am not interested in rules or conventions. Photography is not a sport." — Bill Brandt

The "rules" of photography you'll find in most textbooks are based on economics.

These techniques work for pros trying to sell something, but have nothing to do with the photographs we (the 99.9% of photographers who are not pros) consider important.

Technique is overrated.

It's nice to have, but many of what we would consider humanity's most important photos of all time aren't even in focus. They break just about every rule you'll find in a textbook.

Those textbook rules, by the way, almost always originate with what a client wanted at some point.

There's only one rule that matters: tell a story with a compelling subject—for you.

Think of it as a Maslow's Hierarchy of Photographic Needs.

Every decent photo needs to tell a story. Telling a story with a compelling subject can make a photo historic. But a step above even those photos is a photo with a subject that is compelling to you, specifically.

UNLEARN PHOTOGRAPHY

"Great photography is about depth of feeling, not depth of field." — Peter Adams

How much about what you've learned as a photographer could you let go of today?

How many of the lessons have never really applied? And how many have applied, but never really mattered? The more you let go of, the more creative freedom you'll rescue and the more time you'll have to photograph.

Unlearning photography may be just as rewarding as learning photography.

THE SNAPSHOT IS KING

"Inherently, we all know that an image isn't measured by its resolution, dynamic range, or anything technical. It's measured by the simple—sometimes profound, other times absurd or humorous or whimsical—effect that it can have upon us." — Chase Jarvis

It seems there's no more damning critique of a photograph than, "It's a snapshot."

This makes no sense.

Snapshots are usually reserved for family, friends, and events, where we'd rather be enjoying ourselves than setting up a tripod. Snapshots discard the old rules of photography and aim for pure emotion. What could be more artistic?

The snapshot gives voice to three-year-olds, the poor and many other groups often considered unworthy of the "art" world.

The truth is the vast majority of photographers take snapshots. The best-selling cameras in the world are optimized for

snapshots. The snapshot is the medium for some of the most important pictures in history.

It's time for the snapshot to get some respect.

Because of the joy a snapshot usually brings to my life, I care for it far more than anything hanging in a gallery.

My inbox is filled with emails that include some variation on the phrase "I only really shoot family photos." I can't imagine a more important subject.

YOUR PARENTS' PHOTOS ARE BETTER THAN YOURS

As a group, we photographers remain obsessed with megapixels, light sensitivity, and prime lenses. The generations before us tended to shoot with whatever was handy. Their results were better.

Their photos of us as kids are grainy, out of focus, discolored, and lacking any logical composition.

And they're wonderful.

They're wonderful because the grain and fading give us the context of time.

The lack of composition revealed monstrously huge cars, long-ago shuttered businesses, and the extremely unfortunate clothing choices of anyone who happened to be passing through the frame.

The paper itself may well have outlasted the lives of the people who took the photos.

What would be lost if those same photos followed the modern rules of photography?

WE NEED NEW SPECS

Speed shouldn't just be measured in the hundredths of seconds it takes to expose an image, but in the time it takes to get your camera out and capture the moment.

Exposure shouldn't just be measured in a histogram. It should be evaluated in the ease by which the image can be exposed to the right people in the right way to maximize impact.

The design of a camera shouldn't be evaluated on day one. The mark of a great design is a camera that looks better after years of hard use because it hits a sweet spot for its user between constraint and utility.

We need new specs.

DECLARE INDEPENDENCE

Independent thought is the scarcest resource in photography today. Not talent. Not money. Not technical ability.

Websites, videos, books, magazines, and even workshops tend to parrot each other. Which photographers have remained interesting throughout? The ones who were doing what the others hadn't considered.

In the 1960s, professional photographers did not usually go on tour with musicians. Those photographers who did wound up shooting unique, timeless images that have made for worthwhile careers and worthwhile lives.

Today, touring with musicians is what the professionals do. It's not unique anymore. It's a well-established process. And it doesn't have the same impact.

What unique images can you bring the world today that the professionals aren't?

The dependence we have on pros to tell us how to shoot and how to present our photography only serves to make our work just like that of the thousands of other photographers who listened to the same message.

Some of the "pros" out there who are dispensing the advice are only professionals at dispensing advice. Some are downright con artists.

How can you tell the difference? You can't. You have to decide if the advice makes sense for your photography. You have to decide if reading this book is a good use of your time. You have to decide if the writer is credible. You have to decide how to spend your time in this hobby. Don't let someone else decide for you.

TIPS

Are not what you need.

Tips are the lowest level of education, appealing to the fearful lizard brain. That's why they're a popular feature in photo publications.

Most tips cannot withstand the simplest of questions: "Why?"

What if you started doing the opposite of these tips? It would probably create more unique photos. Is that so horrible?

Tips are just tiny pellets of stifling reassurance.

PHOTOGRAPHY 'EDUCATION'

I n deciding which photography publications, podcasts and videos are worth your valuable time, it helps to remember that our obsession is not cameras, it's photography.

This eliminates roughly 99% of the filler out there.

Here are a few simple rules worth considering when learning about photography:

Most books could be a blog post or two, and most blog posts could be a sentence or two. Recognize those who don't respect your time. There's courage in brevity.

Know your teacher. Consider who you're giving your time and attention to and whether you're learning anything of value. If not, move along. If you don't find a suitable replacement, you'll regain precious time and maybe learn a thing or two on your own.

Always favor individuals over groups or companies. Individuals have more incentive to be honest and less reason to provide the kind of filler content that may be profitable, but provides little real knowledge. That filler comes at the expense of your time, attention, and money.

Consider the ad-to-content ratio. With more advertisers to

please, the amount of honest content shrinks. If everything is great, anything can be sold.

Cameras will always improve. Will you? Accept that the advance of technology will not necessarily make you a better photographer, and most of what passes for photography education becomes irrelevant.

PASS IT ALONG

The photography world is full of sketchy teachers, but that's all the more reason to share your experiences. Sharing your experiences honestly can have a profound effect on other photographers.

Teaching can also be the best way to learn more about something you've been practicing for years.

Most of us have learned something about photography that's unique. A lot of us have an audience somewhere, no matter how small. Putting the two together will make photography a lot better.

ROLL YOUR OWN

There will always be another online service begging for you to share your photos. They ask you to trade privacy, image rights, and image quality for the privilege of putting your work in front of a lot of viewers with little friction.

Not enough photographers assess the benefits of using these services before jumping right in to the next new one that comes along.

Most of these services will not help you tell a story, effectively edit, or showcase your skills in the best possible light. If you wish to tell a story to the public and avoid the constantly changing, often-onerous terms of service, you need to own the experience of viewing your images.

Take advantage of social networking to call attention to your work and communicate with your fans, but always bring your viewer back to a place you can tailor to create the experience you want your viewers to have.

Don't offer your best work to an environment that changes with the whims of a company that almost certainly doesn't have the interests of your viewers at heart.

SHOULD YOU HAVE A PORTFOLIO?

"Just another couple of snowflakes in the big art establishment blizzard." — Hugh MacLeod

I don't have a portfolio. I don't want one. It serves no purpose I can justify.

I realize why people want it. It's so easy to create an online portfolio today, it's become the gold standard for judging a photographer's worth. Everybody can have one, so everybody should.

But what are you trying to accomplish by assembling a portfolio, online or offline?

Is it attention? If so, that's probably the worst strategy. If you have great stories to tell, there are far better venues for getting attention than a portfolio.

Is it credibility? That's always a losing battle. The closer you get to your goal, the less you innovate. Trends become your friends.

Is it clients? You're trying to be a pro, which is fine, but then

we're talking about commerce, not necessarily art. There's a different set of rules to apply.

Critics will gladly pick apart your portfolio to compensate for their lack of judgment. I don't see a reason to play by their rules.

YOU HAVE A REPUTATION

Marketing phrases like "personal brand" come and go and are mostly the work of marketers who believe that to own something, you must rename it.

Go back decades before such buzzwords pervaded our lives, and you'll find the foundation of this concept was more simply called your "reputation."

A good reputation comes from your work and your interactions with your community.

You have one, whether you want it or not. Whether you care is up to you and your goals as a photographer.

A good reputation is not derived from marketing "hacks" deployed on prospects to promote yourself.

Unfortunately, it often seems that those who are most obsessed about building their personal brands are the first to forget about their reputations.

ARTISTS THRIVE ON CONSTRAINTS

"The enemy of art is the absence of limitations." — Orson Welles

E very new, professional-grade camera aims to remove the photographer another step from the mechanical processes of the camera to "focus on the image."
This has the opposite effect.

Creativity is always enhanced by a constraint. This is true in filmmaking, music, painting, writing, and even photography.

How many times has one of your favorite musicians, whose best album was produced in days using half-borrowed equipment, gone on to spend a year in the studio on their next album, only to produce a mediocre (at best) result?

How many times has a talented filmmaker been given unlimited funds and technical possibilities—only to produce a Jar Jar Binks?

A lesser camera makes you think. Thought is better than

automation in art. Automation leads to commoditization. Your art becomes easily replaceable or worse, forgettable.

The resurgence of film among younger photographers may well turn out to be just a fad, but the reason it makes sense to so many people is the feeling of enhanced creativity it fuels. If you load black-and-white film into your camera, your whole world becomes black and white until a new roll is loaded. That's a very useful constraint.

If you carry a camera with a fixed lens, you must get close to your subjects. That may be the most beneficial of constraints.

Constraints become a necessity because your brain seeks the path of least resistance. Your brain craves the automation. It's less painful. Your brain would love to produce safe, bland fluff. When we enforce a constraint, we throw a boulder into the path of least resistance and force the brain to create a path less traveled.

Your creativity is what makes your images unique. Stop stifling it for an easier "workflow."

Comfort is where art goes to die.

SHOULD YOU PAY FOR CONSTRAINTS?

S hould you pay for constraints? Should you pay *a lot* for constraints?

Leica owners insist that you can and should. I don't agree.

You can buy your way out of a problem, but it doesn't mean you've found the solution. It definitely doesn't mean you've found the creative solution. It may only mean you've bought your way out of creativity.

Constraints come in all price ranges, and the likelihood that your specific set of constraints is perfectly met with the most expensive camera on the market is pretty low.

FIND YOUR BALANCE

"That's the disease you have to fight in any creative field—
ease of use." — Jack White

The more fun something is to use, the more you'll use it. Creativity is spurred when there's just enough pain to prompt thought, but just enough fun to keep you clicking the shutter.

I'd go back to pro-level gear tomorrow if I thought I could rely on my brain to consistently deliver better ideas with automated equipment. That just isn't the way my brain works. If given the chance to be lazy, it will. It'll tell me to use the equipment to produce the same kinds of images I've seen in all the books. I suspect that's true of most people.

That said, gear is not the enemy.

Surrendering creativity for automation is the enemy. Looking for features instead of benefits is the enemy. Not doing the work is the enemy.

Every photographer has to find that boundary between the pain and the fun to be at their most prolific. When's the last time you went looking for yours?

GO AMATEUR

"100% of humans should practice an art. Probably 0% should try to make money off it." — Austin Kleon

Photography is one of the most popular hobbies on the planet, but you'd never know it from most photography content. It's treated as a profession, where the goal is making money, buying more expensive gear, or getting prints into galleries around the world. You're being enticed to "go pro," but that's just not realistic for the vast majority of photographers. In reality, most photographers could benefit from going amateur.

At the time of this book's publication, the U.S. Bureau of Labor Statistics calculated the median pay for a professional photographer at $34,070.00 per year with an estimated 6% decline in jobs over the next 10 years. Most of those who choose to make a living with photography do not make much of a living.

New photographers are dipping their toes in the professional market all the time, making photography a commodity in

areas of the market where creativity has been neglected. Some veterans have stepped up their game in response, most have not. The result is less opportunity for average photographers.

I'm not here to discourage you. No doubt, some of you are professionals already, and some of you have made a few bucks here and there.

But the vast majority of you are not professionals and never will be. Many publications and professionals teaching on the side are hoping you never realize that. Most are pushing a content drug on you. The goal is to treat you as a professional, tempt you to buy like one, and keep you coming back for more. This robs you of time and resources better spent on making the pictures you love.

On your deathbed, will you regret not having made a few extra bucks on your photography? It's more likely you will regret not creating more art.

Stop buying into the assumption that your goal is to make money from photography. Your goal is to create photographs that you love.

For a professional photographer, the photograph is a product. For an amateur photographer, the photograph is a byproduct of a life well lived.

Concentrate on making your images remarkable, instead of marketable. If you photograph what you love to photograph, without regard for money, you'll create better images, which could lead to the possibility of money. Just don't count on the money.

THE PROS AGREE

Professional photographers tend to embrace the philosophy of this book much more quickly than amateurs. How can this be?

It doesn't seem to make sense, but in the email I've received, most of the support for "lesser photography" has come from professionals. The skeptics are almost always amateurs.

It's very common for a professional to say, "I've already scaled down and started experimenting." It's equally common to hear an amateur say, "I'm still buying that fancy new camera, but I will really think about these principles in the future."

It only makes sense when you consider what a cutthroat business professional photography has become.

Only professionals who recognize the value of creativity to differentiate their work are likely to thrive. Those who take the risk, reap the reward.

HOW TO MAKE MONEY WITH YOUR PHOTOGRAPHY

A re you still not content to remain an amateur? Are you still trying to figure out a way to make a few bucks from your photography? Believe it or not, there are two ways to make money with photography that will never die out, even as the rest of the industry mummifies.

The first is to be the absolute best photographer in the world in a niche that makes a lot of money for someone else.

The second is far more attainable.

What the world needs more of now, and for the foreseeable future, is more people with great ideas who just happen to be great photographers.

Visual storytelling was the best way to sell an idea 10,000 years ago, and nothing will change that for at least the rest of your lifetime.

SPEND ON IMAGES, NOT GEAR

"When everyone has access to the same tools, then having a tool isn't much of an advantage." — Seth Godin

The lust for gear is pervasive. It's the fuel that turns any hobby into an industry. In photography, that desire for the latest gadgets has provided the incentive for innovation. There's no doubt it serves an economic purpose. But it only serves to harm creativity.

We need to decide what is going to consume our time, money and attention: our cameras or our images.

If you're reading this, I'm guessing you already own some kind of camera. Inevitably, you're going to feel the pull from ads, catalogs, eBay, and fellow photographers to upgrade. How much sense that makes depends on your goals as a photographer.

You could buy that new prime lens you've been lusting after, or you could buy a plane ticket to a place you've never been and have enough left over for a travel guide. Which would add more to your life experience and to the diversity of your image library?

There are plenty of very fashionable photographers with little in their images to show for it.

For the vast majority of photographers—those who don't rely on their cameras for their income—a simple, usable and pocketable camera is more than enough when you know how to use it properly. Don't expect to see that notion in your typical photography publication. It may anger an advertiser.

Lesser cameras often get a bad rap, simply because there's less money involved, but don't overlook their benefits. They can be used in more places, and without eliciting the reaction of security officials. They're less obtrusive when shooting candids. They can be stashed and retrieved easily in a pocket or plastic bag during bad weather (perhaps making you more likely to venture out for such photography). They have simpler controls, making them more likely to be used fully. Most importantly, they allow the user to always have a camera ready for unexpected opportunities.

Not every small camera can produce poster-sized prints with tack-sharp detail yet. However, most modern photos will never be printed at any size.

Real output is judged by the reaction it evokes in the viewer. Emotions are not measurable in print size or pixels. Your spending more on pixels may make a camera dealer very happy, but it may not do anything for your viewer.

THE PERFECT CAMERA FOR YOU

"Some people love the tools more than the outcomes." — Mark Hurst

There will always be some amateur photographers who refuse to concede that spending on images, not cameras, will improve their photography.

They tend to fall into two camps:

"I use what's appropriate for the kind of photography I shoot."

How many times have you loved a photo because it was "appropriate"?

You say you only have a compact camera and you want to be a bird photographer? That sounds like an incredibly interesting creative problem worth solving. Or you could throw money at the problem and end up with bird photos that look like everyone else's, if you're lucky.

"Gear is part of the fun of photography. It makes me want to shoot more."

Gear was a tremendously fun part of photography for me until I realized gear wasn't about the image, it was about the gear.

Do not attach emotion to the tool. Save it for the images.

The image must come first, unless you want to be a collector or a maker of camera equipment—and there's certainly nothing wrong with that. Honestly, when I used to say this kind of thing, I just wanted a particular lens or camera and was looking for an excuse.

A Buyer's Guide

There may come a time when you actually have to buy a camera of some kind. So, here are few rules that may help you select the best one for you:

1. Check to make sure you don't already have a camera. They're everywhere, and in everything, so you probably do.
2. Discover your pain point. Everyone will have a different pain point—the point at which the brain has to take over from the equipment to produce a desired result. Find that pain point by borrowing and renting cameras.
3. Buy a tank. If possible, buy the camera that best rejects the notion of planned obsolescence.

IS TOTAL AUTOMATION THE FUTURE OF PHOTOGRAPHY?

Yes, and that may serve artists particularly well.

Even though anyone can microwave a frozen dinner, what we really want (and pay good money for) is a dinner prepared by someone who knows what they're doing, has a vision, and doesn't take shortcuts.

Automation in gear will always sell better than the prospect of having to work with a creative problem. Welcome this with open arms. There's no better way to differentiate your work from the masses than to wrestle with a problem everyone else is avoiding—and win.

TELL A STORY

"We've got to stop thinking of ourselves as photographers. We're publishers." — John Stanmeyer

W hy does every major photography award seem to go to the same few outlets: *National Geographic*, *The New York Times* and a handful of interchangeable lifestyle publications?

Why aren't photography how-to publications, which feature the best work of the most-celebrated photographers on the planet, recognized with awards and loved by the same numbers of readers? They feature the best photography has to offer, yet they're read by far fewer and usually as an impulse.

Countless photographers teach you technique and show off their portfolios, but *National Geographic* and a handful of journalistic organizations still bring the most recognition. What do they know that the millions of contenders don't?

Photography that is technically proficient is no longer

enough to inspire. You must tell a story. And while you're telling a story, don't limit yourself to just images.

For years, photographers have been wisely imploring writers to learn to create compelling images to enhance their story-telling. The same argument must be made in reverse. Photographers must learn to write to enhance their storytelling or find a writer to collaborate with. The two skills are inescapably linked now.

This is why it makes no sense for a photographer, with no professional mandate, to keep a portfolio section on their website. Viewers would be better served, and thus photographers would be better served, by telling stories. Those stories are better served with great writing. A picture may be worth a thousand words, but the worth of a great story is incalculable.

It's believed that there may be evolutionary reasons for humans to be attracted to stories, as stories help us anticipate the future. If we're good at figuring out where a situation may go, we're more likely to survive the situation.

Humans don't just want stories, humans *need* stories.

Videography is a combination of several methods of story-telling, not limited to the consumption preferences of a single type of audience. *National Geographic* presents all types of audiences with impeccable storytelling, catered to their consumption styles. That's why they win.

STOP MAKING PHOTOS FOR PHOTOGRAPHERS

The majority of photos I see every day are made to impress other photographers.

"Perfect composition!"

"How did you do that with a <insert inferior device here>?!"

"That ISO range is INSANE!"

How boring we must seem to everyone else.

You have a gift. You see the world in a different way. You've trained your eyes to notice things most people would not.

Why would you use those talents to impress those who have had the same training?

There's a whole world of people out there who could use a great story, and you have the tools (the knowledge that is, not the gear) to deliver the story.

Photographers have been served enough. How could you

change the way you share your photos to let your talents loose on the rest of the world?

BE HONEST, NOT TRUTHFUL

Photography may be at its most powerful when it tells a story. But is that story more powerful when it's a truthful story? I think that's a false pursuit.

In storytelling, there is no truth.

Art is the perception of an artist, usually objectified. That perception will not be the perception of the viewer. The more unique the art/artist, the further from the viewer's perception the story will be, no matter how honest the artist is to their own vision. The story is not truthful, but that doesn't mean it can't reveal truth.

Honesty in storytelling is just being open and vulnerable. Even so, there's nothing your brain will fight harder against.

HONESTY IS YOUR COMPETITIVE ADVANTAGE

This is the everyone-is-trying-to-teach-you-something era.

The quickest way to make money these days is to tell people what they want to hear. Package it in as many appealing formats as possible and launch it to the masses.

Honesty is a much more long-term proposition. It's about reputation. Its about building trust. It's rarely neatly packaged and satisfying, because that's not what the real world is.

If you discover your form of sharing your work with the world is incompatible with the current norms—good! That's what we hope for from artists.

HONESTY IS MORE INTERESTING
THAN TRUTH

Arguments ensue over whether all photographers are liars, or all photographs are lies.

What's more interesting is the debate between "artists" who manipulate the hell out of their images and photographers who attempt to capture a scene as close to "as is" as possible, without boring the viewer.

There's so much gray area in there that you could meter off it. But what's great about it is the difference in the reaction of the viewer.

There's a visceral reaction to "as is" photography. It deeply engages the viewer (see the rise in photojournalism-style wedding photography or the endless photojournalism manipulation controversies as examples). This isn't limited to photography.

When Rage Against the Machine released their ground-breaking debut album, the liner notes informed the listener, "No samples, keyboards or synthesizers used in the making of this recording."

Any movie "based on a true story" is analyzed to death to discover mistakes.

Why are we so emotionally connected to this fictional honesty? The audience loves a good constraint as much as the artist.

DON'T IMPROVE ON PERFECTION

There's an old saying among musicians, "If you can't do it in jeans and a T-shirt, it ain't rock 'n' roll."

If you've committed to being honest in your photography, avoid the temptation to improve the imperfections by dressing up your story.

If you can't say what you need to say in a photograph without resorting to the latest trends in post processing, you're probably not saying much of anything. Concentrate your skills in photography to those things that will put you in the right place at the right time while being adept enough to capture that moment in the most compelling way. Anything more is just covering up your creation.

Don't let someone else's constraints dictate your art.

YOU ALREADY KNOW WHAT TO PHOTOGRAPH

W ay too much time is wasted in search of the kind of photographer you should be. If you've been photographing for a little while, you already know what to photograph.

Whatever it is that you've taken the most photos of (people, animals, landscapes, buildings, etc.) is probably what interests you the most.

Of course, as an artist, you're a naturally curious person, so exploration is a must. But whatever it is that you always come home to is your home.

No matter what area of photography offers the promise of more money or recognition, you will never be as prolific or creative in that area as you are in the area that naturally interests you.

THE MOST IMPORTANT TOOL

"Saying no is actually saying yes to other things." —
Patrick Rhone

I n the days of film, there was a mantra repeated by every
high school and college photography teacher when intro-
ducing their students to the darkroom: the garbage can is
the most important tool in the darkroom.

Effective editing is the skill that separates a decent storyteller
from a great storyteller. Great stories have just as many dud
photos as the decent stories, but the public never sees the duds.

Be liberal with your use of the trash. It's your friend. An
editorial photographer at a major magazine may take thousands
of photos for a feature and publish only five in the story. Being
conservative with what you show to the world protects your
reputation and tells a better story.

A lesser photographer takes this principle a step further.

As much as editing may separate decent stories from great
stories, there's another principle that separates the great stories

from the absolute best. The best storytellers eliminate photographs before they even begin shooting. They pre-edit. They determine what isn't worth their effort to free up their time for the things that may prove to be remarkable.

There's a reason articles abound on how to take photos of waterfalls and fireworks. It's because everyone does it. It's not unique. There are times when it makes sense to put down the camera and take in the world around you. You'll often find a scene no other photographer is covering. One of my photography professors, Monte Gerlach, put it this way: whenever there is a sunset in front of you, turn around and start shooting what's behind you.

If you can find it on a postcard, it's already been covered pretty well and by better photographers than you. It's probably time to move on to a more unique scene. The throngs of budding photographers, reading how-to articles, will take care of the dew-covered flower close-ups for you. Create something you care about, and it will rarely be a cliche.

INSPIRATION IS SCHEDULED

Every successful photographer I've known schedules their projects.

Countless studies and interviews with my photo heroes confirm: Inspiration doesn't "strike." Inspiration is scheduled. It happens when you allow it the time and attention it deserves.

It also has a better name: work.

INSPIRING PHOTOGRAPHS...

C an teach you a lot about basics of photography.
Can expose you to new techniques and photographers.
Can provide great fodder for sharing.
Can be the ultimate creativity-killing distraction.

YOU ARE A REAL PHOTOGRAPHER

Decide for yourself, but I've yet to hear a convincing argument opposing these definitions:

Objective Words

Photographer: Someone who makes photographs.

Professional Photographer: Someone who makes the majority of their income from photography.

Amateur Photographer: Someone who does not make the majority of their income from photography.

Subjective Words

Good Photographer: The "rules" of photography that are used to judge the collected images of a photographer are almost entirely commerce-based and applicable only to professional photographers. You might as well just ask how much money the photographer makes. There's no objective way to measure whether a photographer is "good" or "bad."

Real Photographer: This one really stinks of arrogance.

Some believe you're not a "real" photographer if you don't have a "real" camera (whatever that means). Some believe you're not a "real" photographer if you don't dedicate a certain amount of time to the craft. The truth is, 99.9% of photographers are amateurs, and the vast majority of them have a phone as their primary tool. If you're looking for what's numerically "real," it's an amateur with a phone.

Serious Photographer: See the above two definitions.

Advanced Amateur Photographer: Amateurs who are embarrassed to be lumped in with those who don't use a "real" camera.

LONGEVITY

The longevity of an interesting photograph is inversely proportional to the lack of longevity in the subject.

I've spent half of my almost thirty years in photography on landscape photography. Now, as I digitize and archive that collection, I realize most of the subjects I captured appear exactly the same today as the day I took the original photo.

Plus, the number of photographers traveling those same back trails has increased exponentially.

This means, even if I were a modern-day Ansel Adams, my best photos from those years have probably been duplicated by dozens of like-minded photographers.

So, what about photography subjects is still scarce?

Scarcity must be sought in subjects that won't be the same in 10 years or even 10 seconds—in the fleeting moments.

For those who take naturally to people-based photography, this theory is nothing new, and it's easy to implement. But for those of us who tell stories with and without people, including landscape, architecture, and abstract photographers, the search must begin for fleeting moments within our favorite subjects.

A GIFT GUIDE FOR PHOTOGRAPHERS

Every year, around the holidays especially, photographers are bombarded with gift guides, which often involve a kickback for the guide writers.

Here's an honest guide of what to get the lesser photographer in your life, with nary a kickback in sight. Refer to this every holiday season:

Education

Workshops from trustworthy photographers and local classes can up a photographer's game beyond the fastest of new lenses.

Travel

This adds experience and opportunity to a photographer's toolkit.

Books

This is a little trickier. Be discerning. Seek out the masters, but question everything.

Time

Volunteer to do some errands or babysit so the photographer in your life can go out and shoot more.

PHOTOGRAPHY AS FASHION

Here's to the fashionistas:

to the ones who wear a camera to complement their clothing

to the ones who agonize over the number of compartments in their bags

to the ones who wouldn't be caught dead with black lenses on their Canons

to the ones whose judgment of an image is shaped by who and what made it

to the ones who lament the loss of their safe business models

to the ones who wish they were born a few decades earlier

to the ones who scoff at hobbyists and amateurs

to the ones who talk about creativity, then fully automate their shooting

Thank you. You make it so much easier for the artists to stand out.

THE 'SELF-TAUGHT' LIE

No one is self-taught. We all learn from each other, for better or worse.

No one arrives in photography. It's a constant learning process, and if you're not open to learning from others, you're at a huge disadvantage.

Lots of photographers have come before you. They've made a lifetime of trivial mistakes. There's nothing noble in repeating them yourself.

I've never met an expert that wasn't dead wrong about something. I've never met an amateur who couldn't teach me something.

PROPER MAINTENANCE OF YOUR GEAR

Your photography improves with time and experience. Your responsibility is to ensure the most important piece of gear you have, your brain, gets to where the pictures are for as long as possible.

THE BEST PHOTOS OF THE YEAR

Every year we're told what the best photos of the past year were by many publications. They're always wrong. If you want to identify the real best photos of year, they tend to share the following criteria:

They are too personal to be found in any publication.

They are probably on your phone.

They are dulled by filters and cheap tricks.

They are not subject to criticism.

They are probably not for sale.

They are perfectly imperfect.

THERE'S NOTHING NEW UNDER THE STROBE

The greatest revelations in photography every year are generally repeated revelations. They're made every year in countless books and blogs.

There's nothing wrong with this. In fact, it's necessary.

Discovery is a problem.

It's a problem in music, since unlimited access to unlimited music means TV and radio don't have the influence they once had to tell us who to follow.

It's a problem in news, since the three networks are now millions, and they all have a hard time agreeing on the facts, let alone an agenda.

The problem of discovery is a problem of recovery, as well.

Our notebooks are now infinite. We can collect everything, so we spend precious little time reviewing anything.

Photography truths have remained unchanged for a hundred years, but that doesn't mean any of us can recall them at a moment's notice or apply them to our current projects.

I'm grateful for those who spend the time to remix information and serve it to us in new ways. It's helpful. But I'm aware there's nothing new there.

Collecting information is easy. Reviewing and applying information is hard.

LIVE FIRST

"You just have to live and life will give you pictures." —
Henri Cartier-Bresson

Life happens between frames. If you don't put down the camera to experience your subject, how can you bring anything uniquely personal to the story?

Great photography is just great storytelling. Great storytelling evolves from a life well lived. Live first.

The best camera is already always with you, because the best, sensor is your brain and the best lens is your eyes.

If you don't take the time to live, see, and experience before you photograph, you'll always be a cover band. Your goals will match the experiences of other photographers.

Technique and gear seem insignificant if you have a message. Developing that message is worth at least as much time as you devote to the rest.

WHAT PHOTOGRAPHY REALLY PRODUCES

The print isn't the end product of your photography. Neither is the screen.

The end product is the joy of being present when photographing.

Photography is a rare deep dive into our own brains. It's an appreciation of light, patterns, and texture—the things we tend to ignore in our daily lives for what's more urgent.

It's keeping a lot of us sane. It's even making some of us happy.

Physical and digital products of our photography come and go. They're easily forgotten. As are we.

The only thing that lasts is our awareness of the world around us. Even that will end someday. But what a way to spend a life.

TAKE IT SLOW

History, and science, has shown that the brain is in its most creative state while in a state of conscious rest: daydreaming, in the shower, under an apple tree, etc. This is pretty much the opposite of what we value as a society. These periods of rest seem to get more fleeting with age and responsibility, but much of that responsibility we impose on ourselves. If we're seeking to find better ideas and more of them, we must first do no harm.

Here are a few things I've been paying less attention to, in an effort to take life a little slower.

Productivity

"Resistance," a term coined by Steven Pressfield and popularized by Seth Godin, is used to describe the anything artists use to distract themselves from the pain of accomplishing projects and facing criticism. From obsessively cleaning the house to checking social media, Resistance comes in all forms. Its sole purpose is to kill creative accomplishment.

The popularity of productivity apps and books over the past two decades has been Resistance's greatest ally. It's become a comfort to fiddle with our projects, which means we're not accomplishing them.

I've learned that if I'm thinking about productivity, I don't have enough enthusiasm for my projects.

I've also learned that habits are far more powerful than projects. If I take a few hours to write or photograph every day, the product will build up much faster and easier than if I map out every little detail of what I think I might do.

Everyone wants to be more efficient. But no one would want to describe their art as "efficient." Groundbreaking art tends to be incredibly inefficient in its making.

The News

The news is dangerous to your mental and creative health. Numerous studies confirm aspects of this sentiment, but don't just take my word for it. *The Guardian* (an actual newspaper) recently ran an article with the lede:

"News is bad for your health. It leads to fear and aggression, and hinders your creativity and ability to think deeply. The solution? Stop consuming it altogether."

Even the newspapers are telling you news is bad for you. Of course, that comes from the news, so anything below the lede is probably inaccurate, invasive, and statist, with an insatiable ad-based business model to feed.

Photography news is even worse than ordinary news. Besides the problem of emptying brains, it also tends to empty pockets.

It's never been easier to ignore the news, especially photography news. Give it a try, and spend more time with your art.

WHAT ARE YOU WILLING TO GIVE UP?

As much as photography adds to our lives, we often forget it comes at a cost.

Besides money, we invest our time, creativity, and attention. When we focus that energy on one thing, it comes at the cost of other things.

To leave this unexamined is a recipe for frustration and anger.

Ask yourself:

What projects am I willing to drop to practice photography?

How much time am I willing to take away from my family/friends/job (if my photography doesn't involve them)?

What is my budget?

What has brought me the best return on my investment in the past?

What am I absolutely not willing to sacrifice?

Amateurs give up the least to enjoy photography. We get to use whatever camera we want and chase an experience to enjoy the experience. The documentation is secondary. The costs in terms of money, time, and effort are minimal. The returns can be enormous.

Artists give up what they choose to give up. This creates all kinds of interesting conflicts. The costs vary. The returns can be enormous.

Professionals give up what someone else chooses. The costs can be enormous. The returns can be enormous.

Photography adds way too much to our lives not to invest in it. That's why you're reading this.

Invest wisely.

WORK ALONE

"Artists work best alone." — Steve Wozniak

About forty years of research on brainstorming has shown that idea generation is most effective as a solitary activity. Collaboration has been shown to aid in refining ideas, but groups tend to create fewer and lower-quality ideas when compared with people creating on their own.

My experience tells me that the work itself is also better when I'm alone. This could be dangerous if your chosen field is wildlife photography, but your brain doesn't care as much about your subject matter as the way it's approached.

As much as other humans may give us comfort by telling us we are on the right track with an idea, art is about pushing ideas past where others are comfortable.

Together, we remain comfortable. Alone, we remain unique.

SUPPORT YOUR LOCAL PHOTOGRAPHER

I'm a member at several websites and buy self-published books from others because I believe in what they do and want to support them.

Unfortunately, there isn't a great tradition of doing this at popular photography sites because most readers are used to the intrusive ads and over-the-top affiliate sales techniques.

Your participation in a photographer's work doesn't have to be monetary, but you'd be surprised just how much participation of any kind can make a real difference.

HOW TO BE CRITIQUED

"Get booed off stage at least once." — Carl King

Many photographers have written to me asking for a critique of their work. Popular sites and services abound for crowdsourced critiques. Magazines run regular features for reader critiques. Some professionals even charge for their critiquing services.

It's only natural to want to know what others think of your work. But are you getting what you need from these critiques?

First, do you know your goal? If your goal is to go pro, by all means, get a professional to critique your work through the lens of their business and aesthetic senses. The harsher the lessons, the quicker you'll improve.

I don't believe that is the goal for most photographers, though. I think most photographers simply wish to become better photographers. Beyond knowing the basics, there's not a lot a professional can offer you in a critique that will help you

become a more unique artist. In fact, a pro may not even recognize unique art. It's not what they've been trained to see.

Professionals need analytical answers about how to improve their results. Artists need new ways to see. The best critiques I've seen are not about an image's technical properties. The best critiques question why the photograph was created in the first place.

COMPARISONS

Never get discouraged by the photographers whose capabilities seem to be leaps and bounds beyond yours.

You've gone down a unique path with your life that no one else can duplicate. So have they. That's where they get their perspective.

Figure out what's different about your perspective and use it.

There is no competition for a creative person. There are only your own assumptions and habits to overcome.

STOLEN IDEAS

People steal ideas from me all the time. I'm fine with stolen ideas—much more so than stolen words.

The whole point of publishing and creativity is to make your ideas available to the world for use.

If you're afraid to release your idea into the world because it may be stolen, that's the wrong fear to have. The greater fear is that it won't be stolen, because it isn't worth the effort to steal.

ALL YOU NEED IS 1

You don't need a certain number of followers, a passive income, a monetization strategy, or "1000 true fans" to justify sharing your work.

All you need is 1.

1 person liked my writing enough to hire me, which has led to a twenty-year career as a professional writer.

1 person liked my dating profile (which is most definitely a writing and photography project) enough to eventually marry me and start a family.

1 fan could be your next business partnership, employer, or spouse.

1 fan justifies your next book, blog, and podcast.

1 fan can give your work all the meaning it ever needs, especially if you're that 1 fan.

RESHOOT YOUR ARCHIVES

My best friend, Tom, had a house fire in the 1990s that destroyed all of his photos and negatives (during his most prolific period as an enthusiastic young hobbyist). As a result, he developed an entirely different way of approaching his archive.

Tom said it was better to revisit the places in those negatives and produce something even better. He told me to throw away my old negatives. He gave me a few hundred new projects in under five seconds, and I couldn't wait to get started.

Life is fleeting, and you can't take your archives with you. The real value in photography is an appreciation of the present.

THE STAKES COULDN'T BE LOWER

Don't let your creative projects make you anxious. This is all about your well-being, about learning and practicing something that makes you a better person. It's supposed to be an all-upside proposition.

If, like me, you find yourself in creative ruts, you'll be tempted to dig further into the rut. You'll wonder what others think. You'll feel like you're failing. You're creating stress out of thin air. And for what?

In these moments, I started repeating this to myself: "The stakes couldn't be lower."

The greatest consequence of your creative failure is learning what not to do in the future. You'll try to convince yourself it's about losing followers (followers you lose easily are not really followers) or losing the respect of those you respect (people don't think about you nearly as much as you think they do).

No, the greatest consequence is learning. It's a pretty sweet deal, actually.

Few people follow your work. Even fewer care. What are you doing with that freedom?

EVERY DAY…

There's a reason not to go out and shoot.
There's a reason to go out and shoot.

The weather isn't perfect, and the lighting stinks.
The weather and lighting help make the photographs unique.

It seems like everything's been done.
It seems like nowhere near enough has been done by you.

It seems like there's no money in photography anymore.
It seems like photography is still the best way to capture a priceless moment.

You may believe you're not the greatest photographer.

You must believe you're greatest photographer to tell your story.

BE GRATEFUL

The one antidote for the jealousy that leads to the obsessive buying of gear and chasing of fame is gratitude.

The fact we have the gear we already have, vision clear enough to appreciate beauty, and the knowledge to capture it makes photographers the luckiest people in the world.

While others let beauty pass them by, we recognize it, experience it, and share it with the world.

Is there a better way to fully live a life?

31475265R00066

Made in the USA
Middletown, DE
01 January 2019